A SHORT BIOGRAPHY OF FRIDA KAHLO

A SHORT BIOGRAPHY OF
Frida Kahlo

Susan DeLand

BENNA BOOKS
A Boutique Press for Artists & Writers
Carlisle, Massachusetts

A Short Biography of Frida Kahlo

Series Editor: Susan DeLand
Written by: Susan DeLand

For Jonathan

Copyright © 2017 Applewood Books, Inc.

978-1-944038-15-1

Front cover: Kahlo, Frida (1907-1954) © ARS, NY
Self-Portrait with Thorn Necklace and Hummingbird, 1940
Nicholas Murray Collection, Harry Ransom Humanities Research Center
The University of Texas at Austin, Austin, Texas, U.S.A.
Photo Credit: Erich Lessing / Art Resource, NY
Back cover: Frida Kahlo
My Grandparents, My Parents, and I (Family Tree), 1936
oil and tempera on zinc, The Museum of Modern Art
© 2017 Banco de México Diego Rivera Frida Kahlo Museums Trust
Mexico, D.F. / Artists Rights Society (ARS), New York

Published by Benna Books
an imprint of Applewood Books
Carlisle, Massachusetts 01741

To request a free copy of our current catalog
featuring our best-selling books, write to:
Applewood Books
P.O. Box 27
Carlisle, MA 01741

Or visit us on the web at: www.awb.com

10 9 8 7 6 5 4 3 2 1
MANUFACTURED IN THE UNITED STATES OF AMERICA

FRIDA KAHLO CREATED A RELATIONSHIP of unprecedented intimacy between her paintings and the viewers. She was Mexico's greatest female artist and painted brutally honest self-portraits that were autobiographical and reveal her physical and psychological wounds.

Magdalena Carmen Frida Kahlo y Calderón was born on July 6, 1907, in the house of her parents, called La Casa Azul, in Coyoacan, a small village in the outskirts of Mexico City. This house is now Museo Frida Kahlo, dedicated to her life and paintings. Frida's father, Guillermo Kahlo, was

born in Pforzheim, Baden-Württemberg, Germany, and named Carl Wilhelm. His father was a painter and a goldsmith. Carl Wilhelm Kahlo attended university but was forced to withdraw after a series of epileptic seizures. Close to this time his mother died and his father remarried. Carl Wilhelm and his stepmother were at odds, and soon he left Germany and sailed to Mexico. Arriving in 1891and settling in the Tehuantepec Isthmus in Oaxaca, he changed his name to the Spanish equivalent, Guillermo. He became a professional photographer. Frida's mother, Matilde Calderon y Gonzalez, was born in Oaxaca, Mexico, of an indigenous father and a mother of Spanish descent. Frida had three sisters: Matilde and Adriana were older and Cristina was the youngest. Frida had two half-sisters from her father's previous marriage, Maria Luisa and Margarita, who were raised in a convent.

For a time in the 1930s, Frida spelled her name "Frieda," signaling her German heritage and alluding to the German word for "peace."

In 1936, Frida painted *My Grandparents, My Parents, and I (Family Tree)* on zinc in the manner of traditional Mexican *retablos*, often called *ex-votos*. She placed

her European family on the right with the ocean in the background. Her maternal side is on the left with an outline of the topography of Mexico. Though this is clearly autobiographical, it was made at the time that Adolf Hitler passed the Nuremberg Laws banning interracial marriage. Frida spoke fluent German and watched the rise of Nazism in Europe. She often employed political messaging in her art, and this painting puts her own interracial family forward as if to confront the Nazi ideology. The composition of the lineage is like a genealogical chart used by the Nazis to determine racial purity. She turned this on its head to affirm her own mixed origin.

Frida's father continued to suffer from epilepsy. His photography business declined during the Mexican Revolution in 1910 because his primary client had been the overthrown government. Frida was three years old when the revolution began. She wrote of her mother rushing the children into the house and hiding as gunfire neared. Her

Frida described her childhood as "very, very sad."

mother was fanatically religious and could be cruel. Frida said that her mother may not have loved her father: Matilde grieved for her first love, having witnessed his suicide. Her relationship with her daughters was tense—so much so that Frida's oldest sister, Matilde, ran away as a teen and had no contact with her parents for years. Though Matilde's piety may have driven a wedge between her and her daughters, Frida rushed home from Detroit in 1932 to be with her when she received a telegram that her mother was dying of breast cancer.

Frida contracted polio when she was six years old, making her right leg shorter and thinner than the left. She later wrote, "It all began with a terrible pain in my right leg from muscle downward. They washed my little leg in a small tub with walnut water and small hot towels." Throughout her life she would wear three or four stockings on her atrophied right leg to make it look normal and shoes with built-up heels. The illness isolated her and she was bullied for her disfigurement. Children taunted her

with the cruel nickname of "Frida, *pato de palo*" (peg leg Frida). She was feisty, though, and hurled curses back at them, refusing to be defined by her infirmity. Her father had great affection for her because of their shared experience of living with a disability.

Guillermo, a photographer and painter, taught Frida about European literature, nature, philosophy, and art history. He encouraged her to exercise and play sports to strengthen her leg. She took up bicycling, roller-skating, swimming, boxing, and wrestling—sports traditionally for boys. Her father also taught her photography, and she eventually helped him retouch, develop, and color photographs.

Frida started school later than her friends because of her illness. Her parents had sent her sisters to convent school, but her father enrolled her in German school. When she was fifteen, she was accepted at the prestigious National Preparatory School in Mexico City, which had only recently begun admitting women. Frida did well academically,

At the time that Frida attended, only thirty-five students were women out of an enrollment of two thousand.

studying natural sciences with the intention of continuing to medical school. She spoke three languages: Spanish, German, and English. She was drawn to intellectual and radical thinkers and made friends among them. They formed a group called the *cachuchas* and were rebellious and liberal, debating politics, philosophy, and Russian classics. A few of these friends became important players in Mexican intellectual circles. Through this group, Frida became interested in socialism and Mexican nationalism. Frida adopted July 7, 1910, the day the Mexican Revolution began, as her birth date, calling herself a *hija de la revolucion* (daughter of the revolution).

In addition to her studies, Frida enjoyed art. She took classes from her father's friend, printmaker Fernando Fernandez. Frida learned typing and shorthand so she could find work to help her family. She was employed at a pharmacy, a lumberyard, and a factory before she apprenticed with Fernandez as an engraver.

September 17, 1925, was a day that for-

It seemed that her father's care and guidance helped her overcome the physical and emotional difficulties of suffering from polio at a young age.

ever changed Kahlo's life. Frida, along with her boyfriend and fellow *cachucha,* Alejandro Gomez Arias, was in a catastrophic accident on the way home from school. The wooden bus they were riding in collided with a streetcar. People died, and Frida suffered near-fatal injuries. She was impaled by a handrail that fractured her pelvis and broke her ribs, legs, and collarbone. Frida wrote, "The handrail pierced me the way a sword pierces a bull." Alejandro was not seriously injured and tore through the wreckage to find Frida. He found her, smashed and broken, near death. A surreal account has been written that when Alejandro found her, her clothes were torn off by the force of the collision, and her body was covered with gold dust from a painter's ripped package. When the ambulance arrived, the medics felt she was too injured to live and were moving on to less injured survivors. Alejandro successfully convinced them to get her to the hospital. In a letter to Alejandro, Frida said, "First we were in another bus, but I had lost my little umbrella, and we got out

It is likely that Alejandro saved Frida's life.

to look for it, that's why we got on that bus, which mutilated me....Because of the tiny little umbrella I was very sad. Life begins tomorrow."

After suffering through polio and the effort of recovering from it, now her body and her life were shattered. Frida was hospitalized for a month and spent many more months in a full body cast recovering at home. Her parents rigged an easel to fit over her bed and a mirror attached to the top. Her father lent her his oil paints and brushes. Frida began painting self-portraits, depicting her anguish and her life interrupted. She explored identity and isolation.

"To begin again, painting things just as I saw them with my own eyes and nothing more."

Frida was eventually able to walk again and returned to work to pay her mounting medical bills. This was not easy. She continued to experience excruciating pain. Her doctors found that in addition to the other injuries,

Throughout her life she would have more than thirty-five surgeries and live in chronic pain.

the accident had displaced three vertebrae, and they encased her in a corset and confined her to bed rest for months more.

Frida and Alejandro exchanged many letters during her lengthy convalescence. She was concerned who she would be and how would she feel in thirty years. Their relationship ended after three years. In 1928, Frida painted a portrait of Alejandro with the inscription: "Alex, with affection I painted your portrait, that he is one of my comrades forever, Frida Kahlo, 30 years later."

Many years later, Frida came upon a *retablo,* a traditional naive painting on tin depicting an illness, made as a religious offering of gratitude. These small paintings contain a narrative describing the accident or illness and appreciation for being cured. It is not a stretch to see the influence in Kahlo's paintings. This one depicted a scene very similar to her accident. She wrote "Coyoacan" on the side of the bus and drew her uni-brow on the forehead of the injured woman. She wrote on the image: "Mr. and Mrs. Guillermo Kahlo and

Kahlo was fascinated by them and collected more than a thousand *retablos,* many still hanging in Museo Frida Kahlo.

Matilde C. de Kahlo give thanks to Our Lady of Sorrows for saving their daughter Frida from the accident which took place in 1925 on the corner of Cuahutmozin and Calzada de Tlalpan."

> *"I have suffered two serious accidents in my life, one in which a streetcar ran over me.... The other accident is Diego."*

By the time that Frida met Diego Rivera, he was an internationally famous artist. He was twenty-one years older than she and corpulent, and he had a notorious reputation. He was also a Communist. Their love was fiery and impossible, yet lifelong.

Kahlo was painting relentlessly now. She admired Rivera's work and went to him to ask for advice on art as a career. He saw her talent and raw expression as truly Mexican and encouraged her to paint. His attention was seductive and their relationship soon became romantic. Before long, Frida appeared in one of Diego's murals, *The Ballad*

of the Proletarian Revolution. She was centrally placed, dressed in a red blouse with a red star symbolizing her commitment to Communism, handing out weapons to fellow rebels. Also difficult for her to resist were the circles Rivera traveled in. He was a star in the circle of elite Mexican artists and intellectuals, and beyond that in America and Europe. At the end of the Mexican Revolution, the government commissioned artists to create works that the illiterate masses could understand to teach them Mexican history. *Los tres grandes*—Rivera, David Alfaro Siqueiros, and José Clemente Orozco—led in cultivating a style that defined Mexican identity. Frida's world expanded well beyond the confines of the bed where much of her life had been spent.

His murals were well known and often controversial. Art was political for Rivera.

Frida and Diego married in 1929. She was twenty-two and he was forty-three. The marriage was opposed by Frida's mother. Frida is said to have told a journalist later, "My father didn't like him because he was a Communist and he looked like a fat, fat, fat Brueghel. He said it was like an elephant

They would divorce in 1939 and marry again a year later in 1940.

marrying a dove." The relationship was tempestuous from the beginning. They separated many times and both had affairs, yet they couldn't be done with one another.

Diego had a string of relationships, two long-term, before Frida. He spent ten years living in Paris with Russian artist Angelina Beloff. They had a son who died young. Later, he was with Guadalupe Marín, a model, for five years. Diego and Lupe Marín had two daughters, Ruth and Guadalupe. Diego enraged Lupe by his frequent affairs with models, artist, and photographers— notably with photographer Tina Modotti. An account relates a scene in which a furious Lupe smashed some of Diego's prized artifacts and served the shards to him in his soup. Ultimately, his infidelity ended their relationship. Frida was young but not unaware of the appetites of the man she married. He was the most famous artist in Mexico, and women flocked to him.

Frida began to wear the traditional Tehuana dress from the Tehuantepec Isthmus, where her father had lived. The clothing was

vibrant in color and pattern and layered with lace and embroidery. It was richly Mexican, which Diego loved. It also paid homage to the power of the matriarchal society of the Tehuantepec. Frida was a strikingly beautiful young woman and the traditional dress set her apart from the trend of European fashion embraced in Mexico. She had her own eclectic flair, such as pairing her dress with Chinese embroidered shoes attached to her leg brace, and wearing sophisticated sunglasses. She wore authentic and exotic jewelry and intricately braided hair ornamented with a tiara of flowers, ribbons, or ropes of colorful yarns. Carlos Fuentes, the renowned Mexican novelist, said "her dress and jewelry distracted from her always-dying body....She was her own opera."

Frida had a love for pets, keeping mischievous dogs, birds, a fawn named Granizo, and several spider monkeys. These pets appear in many of her paintings. Some interpret her monkeys as symbolizing the children she and Diego couldn't have. Traditional Mexican folklore saw them as sym-

The layers of fabric and long skirts effectively hid her deformed leg and cloaked her damaged body.

bols of lust. Early Christian and Mayan art associate monkeys with promiscuity and sin. Knowing of Kahlo's deep knowledge of art history, her placement of her monkeys leads to much speculative interpretation.

> *"Since my subjects have always been my sensations, my states of mind and the profound reactions that life has been producing in me, I have frequently objectified all this in figures of myself, which were the most sincere and real thing that I could do in order to express what I felt inside and outside of myself."*

Kahlo and Rivera were both intensely passionate—about painting, their sexual cravings, their politics, and each other. This was a high-combustion recipe. They both were prolific painters, with Diego already internationally renowned and Frida a rising star. They were also both chroniclers. Rivera's paintings taught history and promoted Marxist and socialist propaganda.

Over a third of Frida's paintings were self-portraits.

Kahlo primarily painted herself, graphically portraying a history of pain, injury, betrayal, passion, and politics. Their marriage was volatile. Frida was openly bisexual; among her female lovers was Josephine Baker, the stunning and infamous entertainer, whom Frida had met in Paris. It is said that Diego had little concern about her female lovers, but the men enraged him.

Diego and Frida moved to the United States for three years in 1931. Rivera had been given a commission to paint a mural in the Rockefeller Center in New York City. Here Frida met many in Rivera's circle of friends and artists. Always political, Rivera caused a controversy by painting a heroic figure of Russian Communist leader Vladimir Lenin into the scene. He refused the demand to paint Lenin out of the mural; Rivera was fired and the mural was destroyed. This was a financial setback and demoralizing. Frida had been in poor health and hospitalized three times that year for an appendectomy, a therapeutic abortion, and foot surgery. In 1934, she insisted that they return home to Mexico.

Rivera kept an exhausting schedule, painting murals in San Francisco and Detroit.

Though their marriage was fraught with infidelities, Diego shattered Frida's heart by having an affair with her younger sister, Cristina. Cristina and Frida were very close. Cristina's own marriage had ended and she struggled raising her children. She frequented Frida and Diego's home and often served as a model for Rivera. At some point, their relationship shifted from familial to intimate. This betrayal by both her husband and her sister devastated Frida. She cut off her long, thick hair and stopped wearing the Tehuana dresses that Diego loved. She painted a self-portrait with cropped hair and gave it to Ella Wolfe, her close friend and wife of Diego's biographer, Bertram Wolfe.

Many years later, in 2003, this painting was sold for well over a million dollars.

Frida left Diego, unable to go on with their relationship. She painted a morbid and bloody image of a woman literally being murdered by life, much as she must have felt with her constant physical pain and the emotional devastation brought on by her husband and sister. She titled the painting *A Few Small Nips*. The reference is rooted in a newspaper account of a murder that

stated a drunk man threw his girlfriend on the bed and stabbed her twenty times. He professed innocence, saying, "I only gave her a few small nips."

Kahlo took her favorite pet spider monkey, Fulang-Chang, and rented an apartment in Mexico City. She was dependent on her husband financially, and this gave her a determination to be a self-sufficient woman. It proved difficult. Her craving for Rivera's approval and her need for him kept him in her life. She went to New York with friends to be away from him. Eventually she concluded that living without him made her unhappy and she had to accept him as he was. In 1935 she wrote a letter to Diego:

Frida continued to see Diego, and their miserable passion persisted.

> *"Liaisons with petticoats, lady teachers of 'English,' gypsy models, assistants with 'good intentions,' 'plenipotentiary emissaries from distant places,' only represent flirtations, and that at bottom you and I love each other dearly....All*

these things have been repeated
throughout the seven years that
we have lived together, and all the
rages I have gone through have
served only to make me understand
in the end that I love you more
than my own skin."

Frida moved back in with Diego and their volatile life together continued. Both were painting with great productivity. Frida was fascinated by important men and women, and many passed through their house. In 1936 she met Isamu Noguchi, famed American sculptor, when he was in Mexico City commissioned to create a relief mural for the Abelardo Rodriguez market. They had a torrid love affair, cut short when Rivera discovered them in bed. Noguchi wrote that he threw on his clothes, scrambled up an orange tree, and fled over the roof. The affair ended, but Isamu remained friends with Kahlo throughout her life.

Rivera, a Mexican Trotskyite, interced-

Frida's dog snatched one of Noguchi's socks as he escaped Rivera's wrath.

ed on behalf of the Russian revolutionary Leon Trotsky in his application for asylum in Mexico in 1937, when he sought political sanctuary from the regime of Joseph Stalin in the Soviet Union. Trotsky and his wife, Natalia, initially lived with Frida and Diego, then moved into Frida's Casa Azul. For their protection, Diego barricaded the house by bricking up the windows and posted twenty-four-hour guards. Soon Trotsky was slipping love notes into books for Kahlo. Leon and Frida spoke to each other only in English, which neither Natalia nor Diego could understand. Their affair was short-lived. Even as Frida was growing tired of Leon, Diego, brandishing a gun, demanded they end the affair. The Trotskys moved out of Casa Azul, though they remained in Mexico. Frida remained friends with Leon and painted a self-portrait dedicated to him. Three years later, in 1940, Trotsky was assassinated by a Stalinist named Ramón Mercader, who assaulted him in the head with an ice ax. Frida was distraught over his murder. She had met

Frida flirtatiously called Leon *"piochitas"* (little goatee).

Mercader once while in Paris and invited him to her house to dine when back in Mexico. This put her under suspicion as a conspirator. She was picked up by police and interrogated for over twelve hours. Ultimately, she was released and no charges were filed against her.

Frida's paintings were beginning to attract attention. Her dream of financial independence from Diego was beginning to come true. In 1938 the actor Edward G. Robinson traveled to Mexico to see her paintings and purchased four of them at $200 apiece. André Breton, the great Surrealist writer, and his wife, Jacqueline Lamba, escaped Nazi-occupied France during World War II and visited Mexico in 1938. Rumors were that Frida and Jacqueline became lovers. Breton greatly admired Kahlo's paintings and organized several exhibitions of her work. Kahlo never knew she was a Surrealist until Breton told her she was. Rivera disagreed, saying she was a Realist. Frida called her work "the frankest expressions of myself."

Breton described Kahlo as a Surrealist, saying, "The art of Frida Kahlo is a ribbon around a bomb."

"I was considered a Surrealist. That's not right. I've never painted dreams. What I showed was my reality."

In November 1938, Kahlo traveled to New York for her first solo exhibition, held at the highly respected Julien Levy Gallery. Levy launched many important artists: Salvador Dali, Lee Miller, and Alberto Giacometti among them. Her Tehuana dress and jewelry caused a stir in the press: "The flutter of the week in Manhattan." Unconsciously patronizing, *Time* magazine lauded "Little Frida's pictures." Though referred to as Diego Rivera's wife, she made an impression and her exhibition was a success, selling over half of her paintings. One of the paintings in the exhibition was the self-portrait *Fulang-Chang and I*. It was in an ornate hand-decorated frame. A close friend in New York, Mary Sklar, admired the painting but purchased another one. Later, in gratitude for the purchase, Kahlo made a frame that matched the one for

André Breton wrote the essay accompanying the exhibition. Isamu Noguchi and Georgia O'Keeffe attended, as well as the former fashion editor of *Vanity Fair*, Clare Boothe Luce.

Fulang-Chang and I and placed a mirror in it. She gave both to Sklar, saying that when Sklar looked at the painting, she would see herself in the mirror and they would be together.

During this time, Kahlo's leg was creating much pain. The deformity by polio was not the only problem; it caused poor circulation, which created further medical issues. Julien Levy offered to take Frida barhopping in Harlem. She had an open sore on the bottom of her foot that would not heal, so it was very difficult for her to walk any distance. This dampened any celebratory activity. Frida became very ill after the exhibition, but this led to finding a physician who healed the sore on her foot and alleviated much of her pain.

Kahlo and Clare Boothe Luce were both upset by the dramatic suicide of their friend, actress, Ziegfeld showgirl, and socialite Dorothy Hale. Hale's life was on a downward spiral both emotionally and financially. Shortly before Kahlo's exhibition, Dorothy invited her close friends to her apartment

for a farewell party, and after they left she jumped to her death from the window of her high-rise luxury apartment. Kahlo suggested that she would paint a *retablo*. Luce agreed and told her to send it to her and she would deliver it to Dorothy's grieving mother. *The Suicide of Dorothy Hale* was to be one of Kahlo's most shocking and controversial paintings. Kahlo depicted Dorothy falling from the window and her dead and bloodied body on the sidewalk below. The blood flowed from her body onto the lower part of the frame. She painted a banner at the bottom of the canvas detailing the tragedy in Spanish. Kahlo painted an angel at the top of the painting with a banner saying, "The Suicide of Dorothy Hale, painted at the request of Clare Boothe Luce, for the mother of Dorothy." Clare was horrified and could not give this painting to Dorothy's mother.

Kahlo and Rivera's relationship was in decline. They spent more time apart and in 1939 divorced. Breton invited Kahlo to Paris, where she exhibited. The Louvre purchased her painting *The Frame*. It was

Ultimately Luce had Noguchi paint out the angel and banner and gave the painting away.

the first work of art by a twentieth-century Mexican artist purchased by the renowned institution. Her career was moving forward, yet, as had happened earlier when they separated over Rivera's affair with her sister, Kahlo couldn't resist the pull of their underlying love for each other. They remarried in San Francisco, California, on December 8, 1940. Frida was motherly toward Diego, calling him "my child, my lover, my universe." They were each other's greatest fans, feeling great pride in each other's work. Diego was bursting when Picasso admired the eyes in one of Frida's paintings. He wrote to a friend, "I recommend her to you, not as a husband, but as an enthusiastic admirer of her work, acid and tender, hard as steel and delicate and fine as a butterfly's wing, loveable as a beautiful smile, and profound and cruel as the bitterness of life."

Frida's medical treatments were attempts to alleviate suffering in her tormented body.

Frida underwent many surgeries and treatments over the years, spending months in bed, constricted in body casts. Between 1940 and 1954 she wore twenty-eight supportive corsets, made from steel, leather,

and plaster; had chronic infections in her hands; and was treated for syphilis. She painted prolifically, chronicling her physical and psychic pain. She and Rivera were deeply politically invested through their actions and their art. After a surgery, Kahlo was encased in yet another plaster body cast. She decorated it quite aggressively with a hammer and sickle, icons of the Communist Party.

Frida and Diego primarily lived in Casa Azul, but Diego maintained his house in San Angel as his refuge and studio. Frida's art became increasingly sought after in the United States and, finally, in Mexico. She became a founding member of the Seminario de Cultura Mexicana, commissioned by the Ministry of Public Education to spread public knowledge of Mexican culture. She planned exhibitions and attended conferences on art in Mexico City. An article by Rivera on Frida's *oeuvre* was published in the journal of the Seminario. Kahlo accepted a teaching position at the reformed Escuela Nacional de Pintura, Escultura y

When Kahlo's health became precarious, she moved the lessons to La Casa Azul.

Grabado "La Esmeralda" in 1943.

Frida spent 1950 in the hospital in Mexico City having bone graft surgery on her spine. She contracted a stubborn infection and required more surgeries. She was discharged to Casa Azul but confined to wheelchair and crutches.

Lola Alvarez Bravo, wife of renowned photographer Manuel Alvarez Bravo, had been a friend and photographer of Frida for many years. She felt that Frida would not live much longer and staged Kahlo's first solo exhibition in Mexico at the Galeria Arte Contemporaneo in April 1953. Kahlo had been ordered by her doctors not to move from her bed, so she had her bed transported to the exhibition.

Frida's health continued to decline. In 1953 her right foot turned gangrenous and her leg was amputated above the knee. Frida struggled with accepting the loss of this limb that had tortured her for so many years and to which she had devoted so much effort in appeasing. She contracted bronchopneumonia, further challenging her resis-

Frida wrote, "Pies para que los quiero, si tengo alas pa'volar? ("Feet, why do I want them if I have wings to fly?").

tance. On July 13, 1954, Frida Kahlo died at the age of forty-seven. There is speculation and lore surrounding her death. The official cause is pulmonary embolism. Other reports say accidental drug overdose, while suicide is often suggested as well. There was no autopsy and all seem plausible in her story. Her final diary entry foretold her end:

> *"I hope the exit is joyful—and I hope never to come back."*

Kahlo's body was taken to the Palacio de Bellas Artes, where she lay in state draped in a Communist flag. The next day a private funeral for family and a few friends was held for her at Panteon Civil de Dolores while hundreds waited outside. She was cremated and her ashes are in a pre-Columbian urn in La Casa Azul. The mystery that was Frida Kahlo remained buried for decades after her death. Diego sealed 20,000 papers and personal items, including 6,500 photographs, until 2007, when a trove of photographs was exhibited. In 2004, over 300 of her Te-

Diego bequeathed her blue house to the state and it was made into a museum dedicated to her life and work in 1958.

huana dresses, skirts, blouses, shawls, hair ornaments, and jewelry were discovered in chests in a room at Casa Azul. They were conserved and exhibited in a fabulous explosion of texture and color.

Diego Rivera, the elephant, who died three years later, wrote in his diary that the day the dove died was the most tragic day of his life, and he realized too late that the most wonderful part of his life had been his love for her.

da Kahlo Frida Kahlo Fri
hlo Frida Kahlo Frida Ka
da Kahlo Frida Kahlo Fri
hlo Frida Kahlo Frida Ka
da Kahlo Frida Kahlo Fri
hlo Frida Kahlo Frida Ka
da Kahlo Frida Kahlo Fri
hlo Frida Kahlo Frida Ka
da Kahlo Frida Kahlo Fri
hlo Frida Kahlo Frida Ka
da Kahlo Frida Kahlo Fri
hlo Frida Kahlo Frida Ka
da Kahlo Frida Kahlo Fri
hlo Frida Kahlo Frida Ka
da Kahlo Frida Kahlo Fri
hlo Frida Kahlo Frida Ka